COLOR
YOUR
WORLD

TOKYO

*A Color-Your-Own
Travel Journal*

EVIE CARRICK
Illustrated by EMMA TAYLOR

ADAMS MEDIA
NEW YORK LONDON TORONTO SYDNEY NEW DELHI

Adams Media
An Imprint of Simon & Schuster, Inc.
100 Technology Center Drive
Stoughton, Massachusetts 02072

First Adams Media trade paperback edition November 2023

ADAMS MEDIA and colophon are registered trademarks of Simon & Schuster, Inc.

For information about special discounts for bulk purchases, please contact Simon & Schuster Special Sales at 1-866-506-1949 or business@simonandschuster.com.

The Simon & Schuster Speakers Bureau can bring authors to your live event. For more information or to book an event, contact the Simon & Schuster Speakers Bureau at 1-866-248-3049 or visit our website at www.simonspeakers.com.

Interior design by Michelle Kelly
Illustrations by Emma Taylor
Interior images © 123RF

Manufactured in China

10 9 8 7 6 5 4 3 2 1

ISBN 978-1-5072-2149-5

Contents

Introduction

From the Sensō-ji temple to the Tokyo Skytree to lesser-known locales like the quaint Monzen-Nakachō neighborhood, the city of Tokyo is a unique metropolitan area that showcases both a fascinating history and a modern, high-tech flair. Whether you see these sites in person or just imagine visiting, the cherry blossom trees, neon-lit streets, and unique architecture lend themselves to coloring pages that you can fill in as creatively as you'd like.

This coloring journal guides you through the very best of Tokyo and is perfect for travelers of all kinds—from repeat visitors to those who prefer to daydream from afar. Add your own color to the stately Imperial Palace, the iconic Mount Fuji, or the elaborate gardens of Shinjuku Gyoen—whether on the plane to Japan or from the comfort of your own home. You can also read fascinating background information about each of the thirty sites (arranged by their ward, an area similar to a borough of New York City), along with insider tidbits that will make you feel like a real Tokyo resident. Use the journal space provided with each site to record any notes or research you do, to recall your experiences during your visit there, or to simply write down your thoughts about each incredible place.

Whether this book serves as a travel guide for your next trip to Tokyo, rekindles memories of a past visit, or provides an escape from your everyday life, let *Color Your World: Tokyo* whisk you away to this ancient yet thoroughly modern city. Grab your pen and colored pencils, awaken your adventurous spirit, and relish Tokyo's unique cosmopolitan buzz.

Tokyo Tower

..

4 Chōme-2-8 Shibakōen,
Minato Ward,
Tokyo 105-0011
Est. 1958

Tokyo Tower is a structure with a very practical purpose—housing communication and broadcast signals—but for most visitors, it is one of the city's most recognizable sites and an observation tower. The Tokyo Tower is to Tokyo what the Eiffel Tower is to Paris and, in fact, the design of the Tokyo Tower was inspired by the Eiffel—with a twist: The lattice tower is painted an eye-catching white and orange. It sits above Foot Town, a four-story building featuring museums, restaurants, and shops. The tower has two observation decks: a two-story main deck at 490 feet, and a smaller top deck that sits at 819 feet.

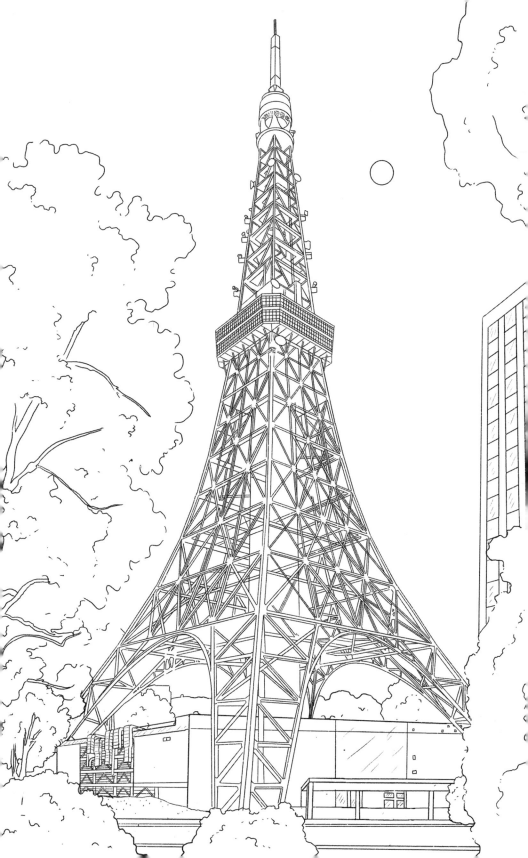

Akihabara

...

Neighborhood west of Akihabara Station,
Chiyoda Ward,
Tokyo

The Akihabara neighborhood of Tokyo is aptly nicknamed "Electric Town." The buildings are covered in neon lights and the buzz and beep of electronics is constant. Shop after shop is packed to the brim with video games, TVs, cameras, and manga. In recent history, Akihabara has emerged as a center of *otaku* culture, with stores specializing in the collectibles of every anime and manga character you can imagine. The neighborhood is also the birthplace of some of the city's iconic maid cafés, where servers dress as maids and act as servants to the customers. The servers also cosplay based on common manga and anime character types. Though these cafés used to have niche appeal, they have recently become a popular tourist activity for all types of people.

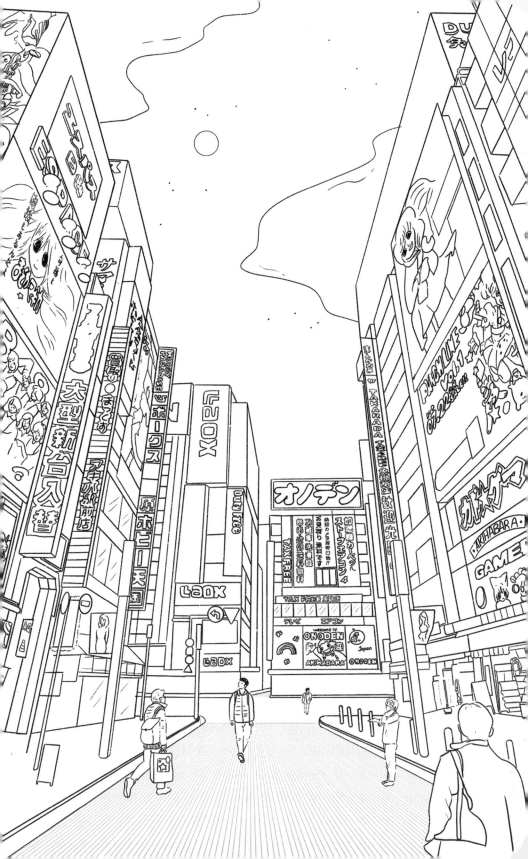

The Imperial Palace

1-1 Chiyoda,

Chiyoda Ward,

Tokyo 100-8111

Japan has a royal family, although this particular lineage is known as the "imperial family" and instead of a king or queen, they have an emperor. In modern times, the imperial family has no role in the government, but does perform ceremonial and social duties. The main residence for this noble family is the Imperial Palace, a large parklike compound in the heart of Tokyo. It's built on the ruins of the Edo Castle, which burned down in 1873 (Edo was the name of the city of Tokyo until 1868). In addition to several palaces and gardens, the site is surrounded by moats. This fairy-tale-like layout makes the approach to the palace spectacular. Tours of parts of the grounds are offered regularly, and on special occasions visitors can cross the iconic Nijubashi Bridge.

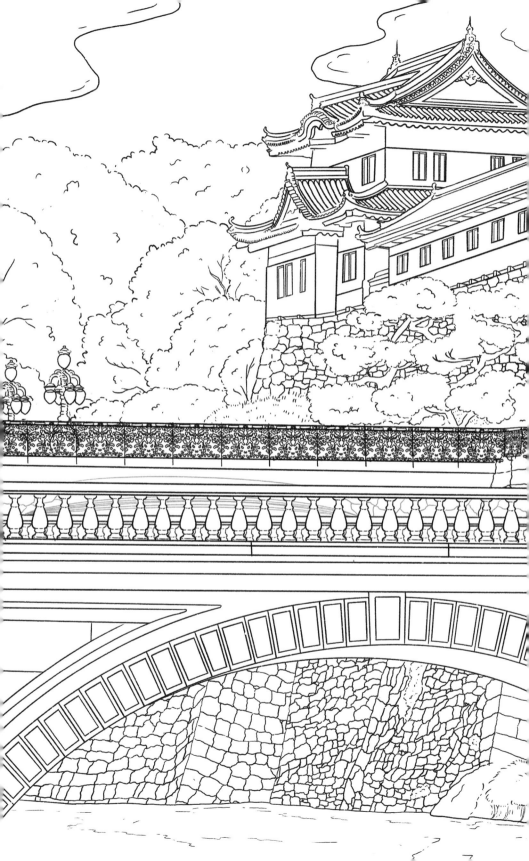

Nine Hours Capsule Hotel

Various locations,
including Chiyoda Ward

Spending the night in a capsule hotel, where your room is the size of a small bed, has become something of a novelty. But the compact form of lodging, which was developed in Japan in the late 1970s, was born out of necessity. The human-sized rooms are often used by Japanese businesspeople, who work long hours and don't have time to make the trip home, and by travelers looking for inexpensive, basic accommodations. At one capsule hotel chain, Nine Hours, guests crawl through the round opening of their assigned capsule and find themselves in their own cozy bubble—with adequate privacy, fresh linens, and reading lights. Guests also get personal luggage lockers for storing their belongings and access to shared bathrooms and showers.

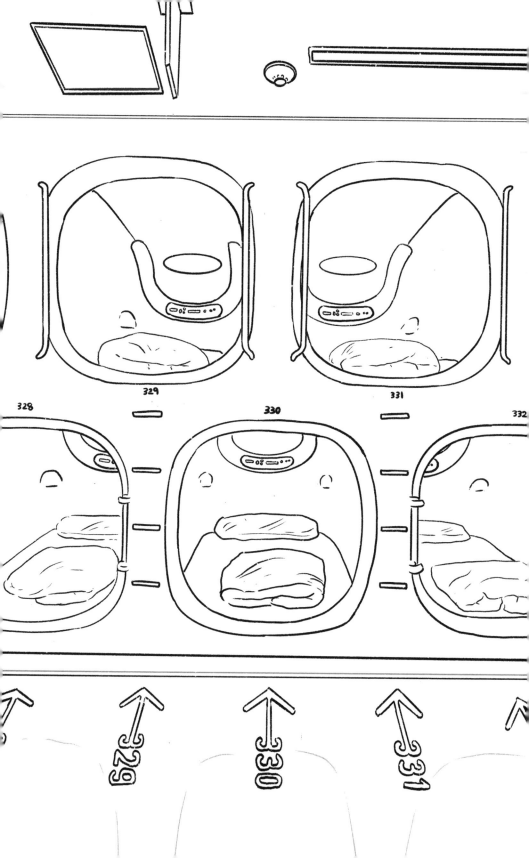

Oedo Antique Market

3 Chōme-5-1 Marunouchi,
Chiyoda Ward,
Tokyo 100-0005
Est. 2003

At this expansive outdoor market, you'll find around two hundred fifty vendors selling everything from Japanese pottery and tableware to kimonos and jewelry. In addition to antiques, there's a great selection of handmade clothes and accessories created from vintage fabrics and kimonos. Entrance into Oedo—the biggest outdoor antique market in Japan—is free, and the range of items available is staggering. Unlike some markets, the price for each item at Oedo is set—this is not the place to haggle. The fun takes place the first and third Sunday of every month at the Tokyo International Forum's open-air plaza, and once a month at its Yoyogi Park location.

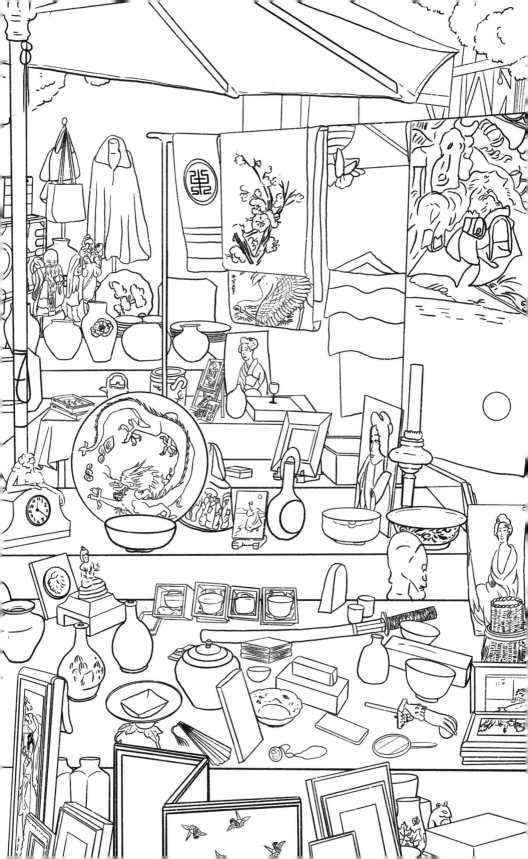

Kabuki-za Theatre

...

4 Chōme-12-15 Ginza,
Chūō Ward,
Tokyo 104-0061
Est. 1889

One of the most iconic art forms to come out of Japan is *kabuki* (the root of which means "song and dance"), a theatrical performance where actors don elaborate makeup and colorful costumes and put on a dramatic production that involves dance. The center for traditional *kabuki* is the aptly named Kabuki-za Theatre, which started as a wooden structure in 1889 and was rebuilt in 2013 after being demolished several times. The relatively new theater still has a distinct look, especially compared to its skyscraper neighbors. The building has a Baroque Japanese revivalist style and is reminiscent of Edo-era temples and Japanese castles. Inside the building, the *kabuki* magic takes place nearly every day—often with two daily performances during a program's run—and is translated for English-speaking audience members through pamphlets and a captioning service.

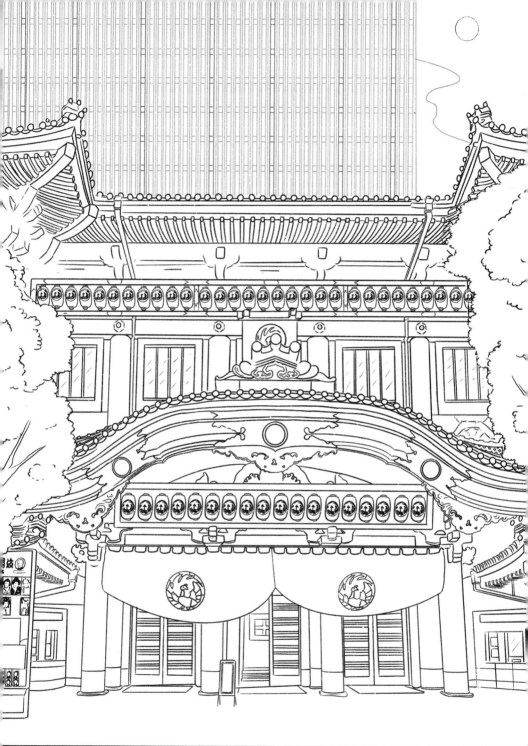

Tsukiji Outer Market

4 Chōme-16-2 Tsukiji,
Chūō Ward,
Tokyo 104-0045

Although Toyosu Market is the largest wholesale fish market in Tokyo, the heart of the city's fishing industry is in the food stalls that make up the Tsukiji Outer Market. (*Tsukiji* means "reclaimed land" or "constructed land"—the site was originally made from land reclaimed from Tokyo Bay.) At Tsukiji Outer Market, you'll find the freshest fish in Tokyo—in fact, it was likely caught, processed at Toyosu, and sliced into bite-sized pieces of sashimi within the last couple hours. Restaurants showcase the morning's catch of tuna, *unagi* ("eel"), and *uni* ("sea urchin") on mountains of shaved ice, while colorful produce stands and retail shops selling food-related goods—think spices and knives—round out the market's offerings. The best time to go is early in the morning, when the fish has just been delivered and sashimi breakfasts abound.

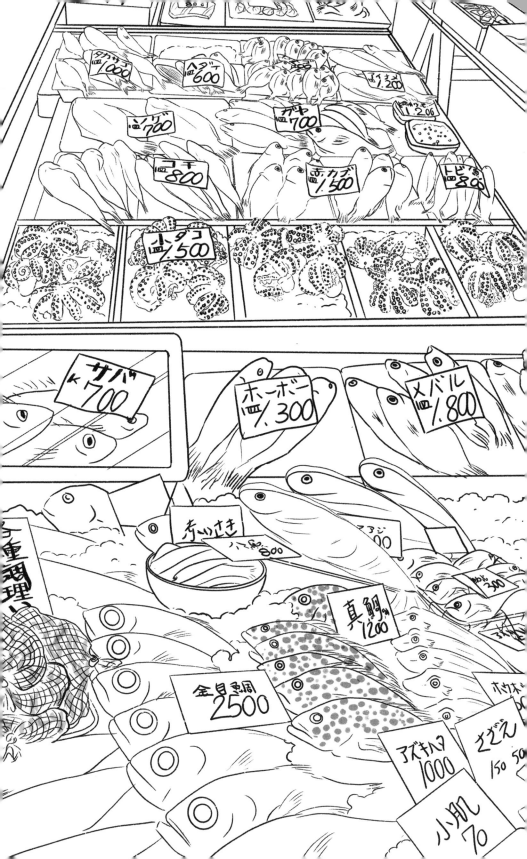

Monzen-Nakachō

Kōtō Ward,
Tokyo 135-0048

Once you're in it, it's hard to believe that the neighborhood of Monzen-Nakachō is in Tokyo. The Fukagawa Fudōdō temple is the heart of this part of the city, and continues to hold Buddhist fire ceremonies (featuring sutra chanting and *taiko* drumming) five times a day. The neighborhood's old-school *shitamachi* ("downtown") atmosphere is alive and well, and you're just as likely to find a traditional shop selling *tsukudani* (meat, seafood, or seaweed cooked in soy sauce and mirin) as you are to find a hip coffee shop.

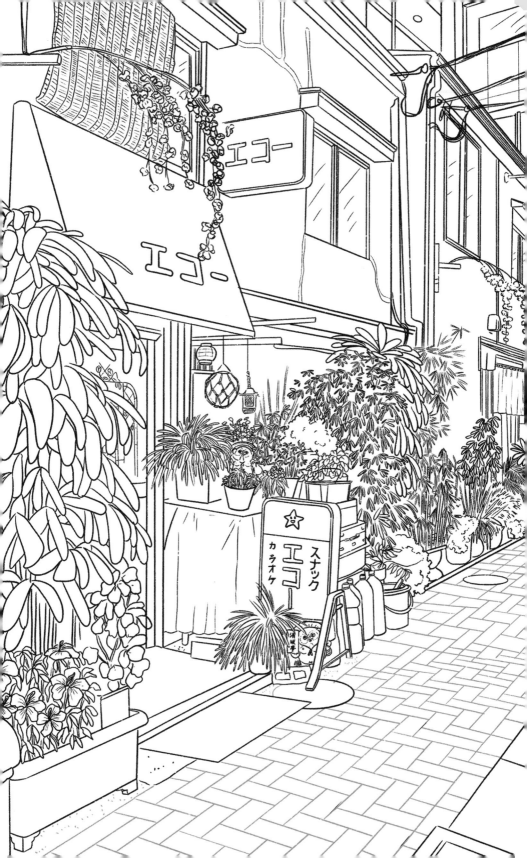

Tokyo Skytree

1 Chōme-1-2 Oshiage,
Sumida Ward,
Tokyo 131-0045
Est. 2012

The Tokyo Skytree is more than a broadcasting tower and Tokyo's tallest structure (at more than two thousand feet)—it is one of the tallest structures in the world and feels like a city within a city. It houses a full five floors of shopping and dining, and even has an aquarium. The best views are found from the tower's highest observation point, Sorakara Point, which is accessed via a glass pathway designed to make you feel as though you are walking in the sky. From Sorakara Point's 1,480-foot-high view, Tokyo's endless sprawl is visible, along with the Sensō-ji temple complex across the Sumida River and the silhouette of Mount Fuji in the distance.

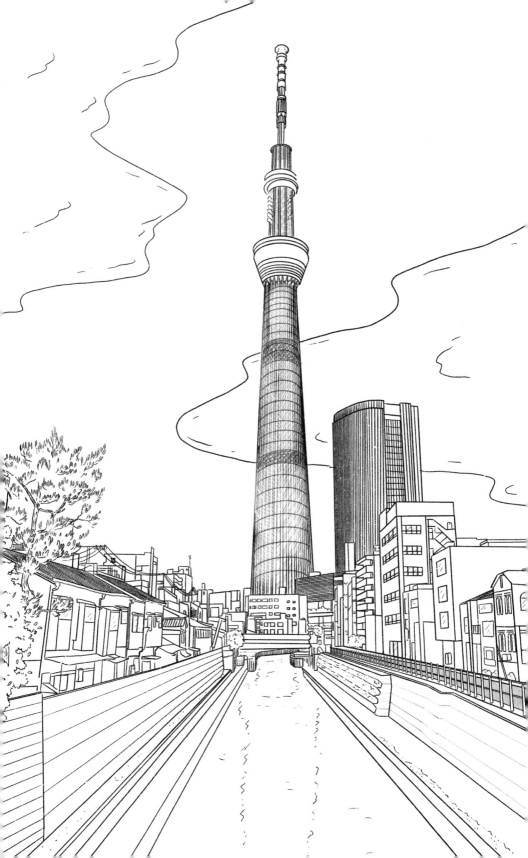

Ryōgoku Kokugikan

1 Chōme-3-28 Yokoami,
Sumida Ward,
Tokyo 130-0015
Est. 1985

Sumo is to Japan what baseball is to the US. But Japan's national sport has roots that date back to ancient times, when the wrestlers performed for Shinto deities. These days, many of the religious rituals remain—including the act of throwing salt before a match to cleanse impurities. In Tokyo, the action takes place in Ryōgoku Kokugikan, the city's main sumo stadium. Inside the Ryōgoku Kokugikan's hallowed walls, heavyweight sumo wrestlers come face-to-face in a match of skill, speed, and size. Tokyo's sumo tournaments take place in January, May, and September, and run over the course of fifteen days.

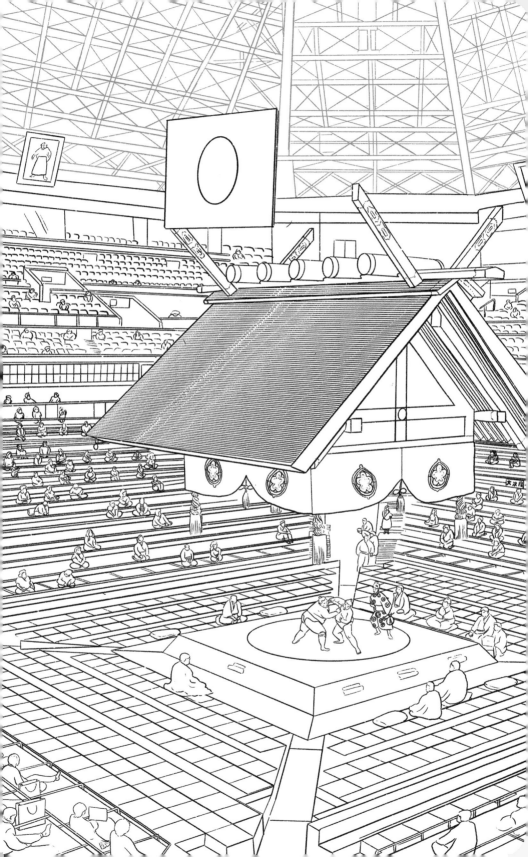

Sensō-ji

2 Chōme-3-1 Asakusa,
Taitō Ward,
Tokyo 111-0032
Est. A.D. 645

Tokyo's oldest temple has long drawn worshippers from all over the globe. The ancient Buddhist temple sits regally at the end of a busy shopping street that's lined with vendors. The shops feature culinary delights like *ningyo-yaki*, a sweet cake filled with red bean paste, and *kibi dango*, skewered mochi-like dumplings. At the Hōzōmon Gate, the atmosphere changes. The jewel of the complex, Sensō-ji temple, is straight ahead. Locals take a moment to wash their hands in the fountain, touch the continual plume of incense smoke, and say their prayers at the offertory box. To the left of the temple is a five-story pagoda building that was built in A.D. 942 and houses some of the Buddha's ashes.

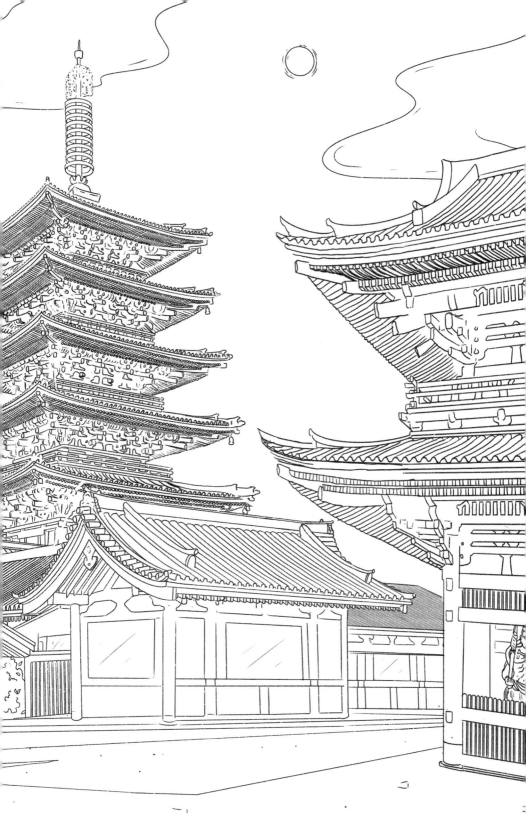

Kappabashi Street

3 Chōme-18-2 Matsugaya,
Taitō Ward,
Tokyo 110-0036

On Kappabashi Street, also known as Kitchen Town, stacks of bowls and plates sit next to bundles of ramen soup spoons and chopsticks. While the street has a very practical purpose of supplying restaurants with the tools they need to operate, it also features row after row of realistic-looking plastic foods. These plastic replicas—of everything from a bowl of soba to a fried shrimp—are purchased by restaurants to showcase their dishes at their shops. The plastic foods have made such an impression on travelers that the shops on Kappabashi Street now sell the plastic foods on earrings, key chains, and magnets, so people can walk away with their favorite sushi roll on a necklace or provide the sweet tooth in their family with a never-melting ice cream cone.

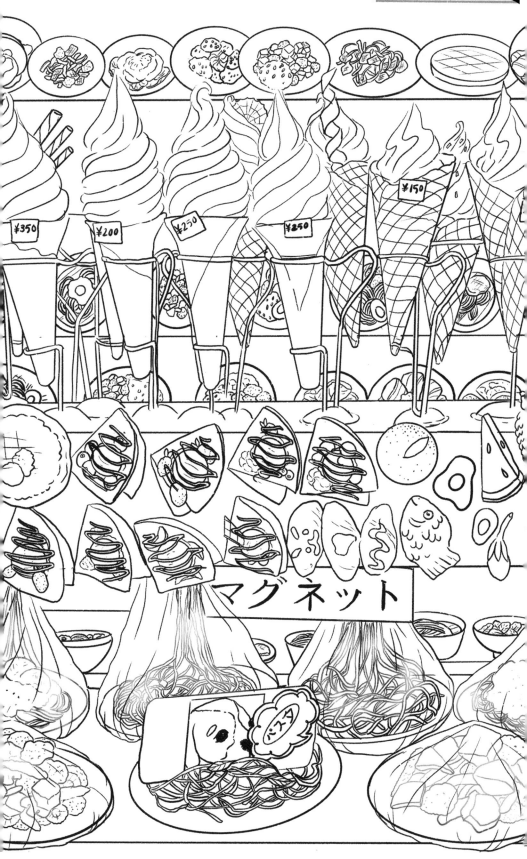

Ueno Zoo

......................................

9-83 Uenokoen,
Taitō Ward,
Tokyo 110-8711
Est. 1882

Ueno Zoo is Japan's oldest zoo and has a central location in the northwestern part of Ueno Park. The zoo houses more than three thousand animals and four hundred species, including Japan's beloved panda family, led by father Ri Ri and mother Shin Shin. The parents have a daughter, Xiang Xiang (who was sent to China in 2023), and twins, Xiao Xiao and Lei Lei. Pandas aside, the Ueno Zoo is known for their work breeding endangered species, and the zoo includes areas called Gorilla Woods and Tiger Forest to aid in those efforts. Visitors will also find a five-story pagoda and a historic tea ceremony house on the grounds.

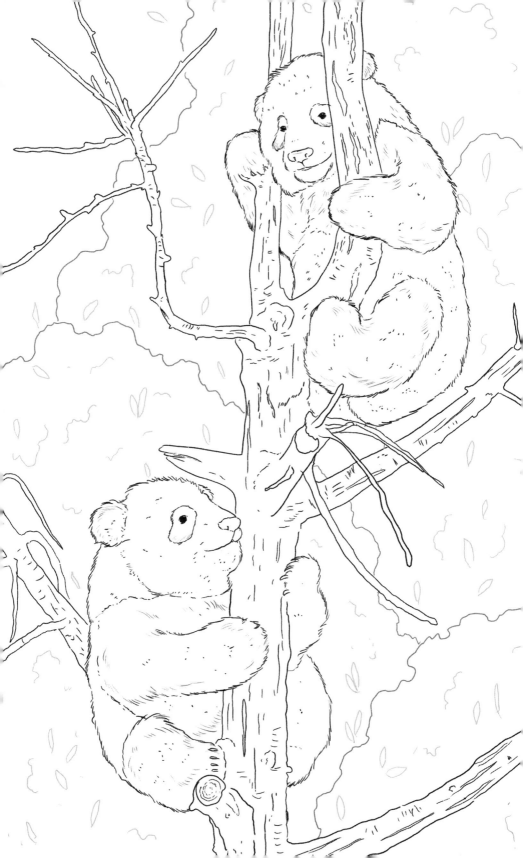

Tokyo National Museum

...

13-9 Uenokoen,

Taitō Ward,

Tokyo 110-8712

Est. 1872

The Tokyo National Museum has a host of superlatives associated with it: It is the largest art museum in Japan, the oldest national museum in Japan, and one of the largest art museums in the world. It specializes in ancient and medieval Japanese art and also has a huge collection of artwork from around Asia, including an impressive array of Greco-Buddhist art. At any given time, there are three thousand items on display, but the museum's collection boasts around 120,000 pieces, including eighty-nine designated as National Treasures (very precious artifacts designated by Japan's Agency for Cultural Affairs). The Tokyo National Museum sits within the expansive Ueno Park, which also houses the Tokyo Metropolitan Art Museum, the National Museum of Nature and Science, and the Ueno Zoo.

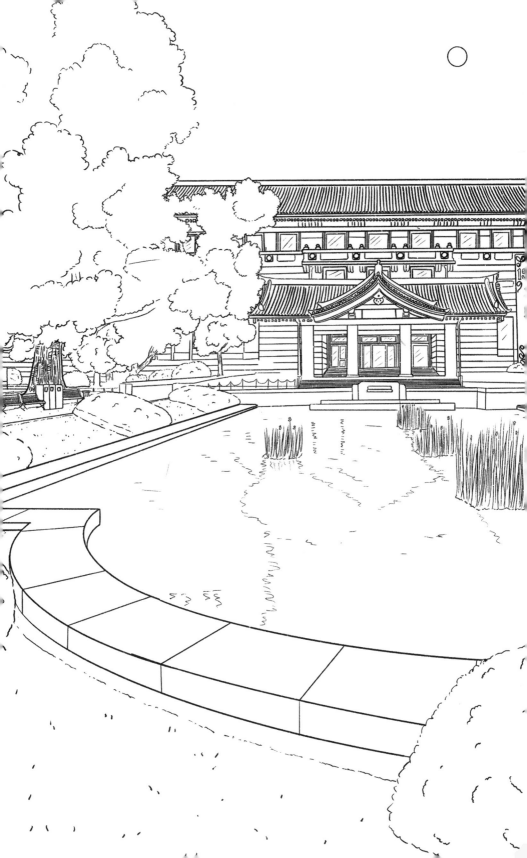

Nezu Shrine

1 Chōme-28-9 Nezu,

Bunkyō Ward,

Tokyo 113-0031

Est. 1705

At the Nezu Shrine, which is one of the oldest places of worship in the city, visitors walk under a tunnel of bright *torii* gates on their journey to the shrine. The trip under the *torii* gates is meant to represent a transition of sorts—from the mundane, human world into the sacred, Shinto religious space. The greenery that surrounds the ascent complements the reddish-orange gates, resulting in a bright, colorful scene. The shrine area also includes a series of historic structures as well as fishponds and viewing platforms, which make for a relaxing end to the spiritual journey.

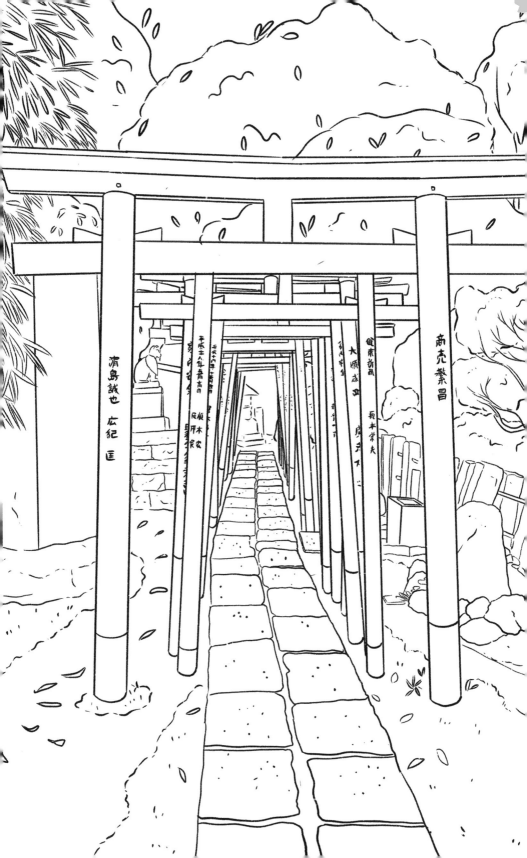

Sosakumenkobo Nakiryu

2 Chōme-34-4 Minamiotsuka,
Toshima Ward,
Tokyo 170-0005
Est. 2012

Ramen restaurants in Japan have historically catered to solo diners, who come to eat a quick meal and leave. But for a dish that is often eaten on the go, a bowl of ramen soup can be surprisingly complex. And arguably no bowl of ramen is more complex than what you'll find at Sosakumenkobo Nakiryu, a standard-looking ramen spot that has maintained a coveted Michelin star since 2017. The tiny restaurant has just a handful of bar seats to accommodate the line that invariably leads out the door, and ordering is done via vending machine. The signature dishes at Sosakumenkobo Nakiryu are their soy sauce ramen and dan dan noodles, both of which rely on a special broth that's made using a whole chicken, oysters, kombu, and beef bones.

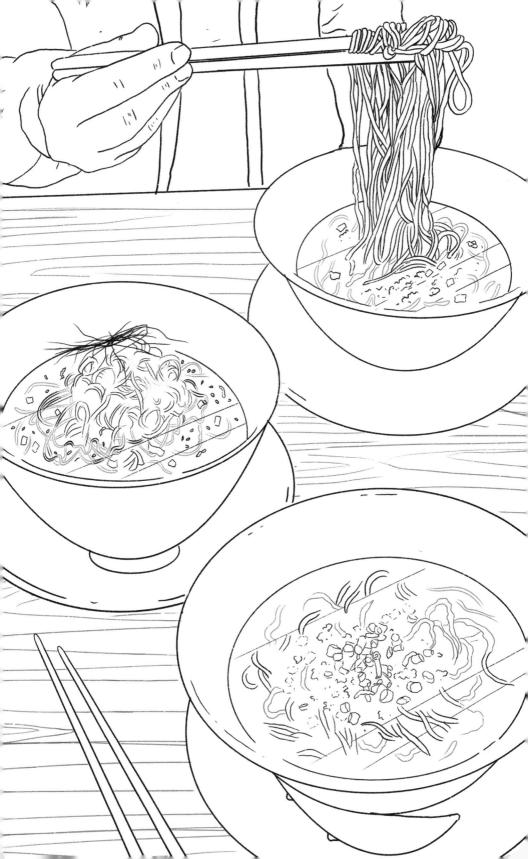

Maenohara Onsen Sayano Yudokoro

3 Chōme-41-1 Maenocho,
Itabashi Ward,
Tokyo 174-0063
Est. 2005

Maenohara Onsen Sayano Yudokoro is a traditional bathhouse, known as an *onsen* in Japan, that is fed by natural spring water and surrounded by lush gardens. At Sayano Yudokoro, visitors can soak alfresco in one of the small spring-fed tubs, join fellow soakers in the larger outdoor pool, or explore the indoor pools. There's also a covered, open-air private bath. The water at Sayano Yudokoro has a high natural salt content and several minerals that provide a unique bathing experience. There are also dry and steam saunas and a room lined with heated rocks that emit therapeutic negative ions and far infrared rays.

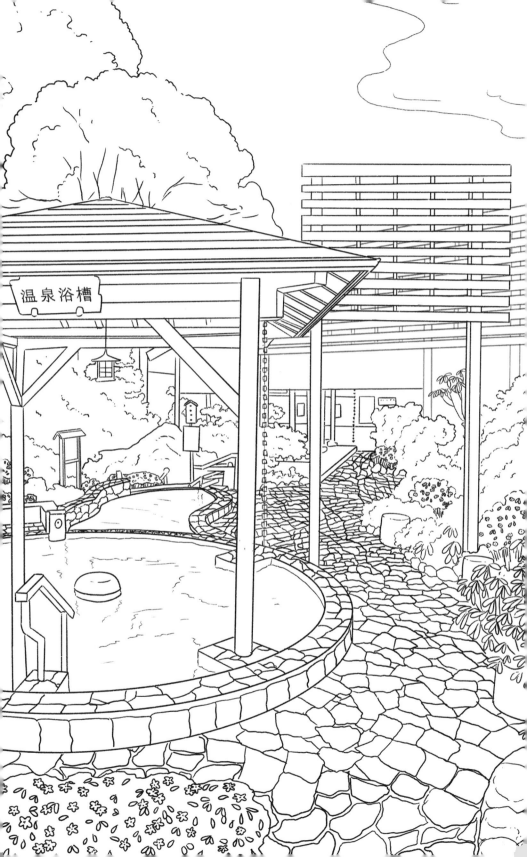

Isetan Shinjuku

3 Chōme-14-1 Shinjuku,
Shinjuku Ward,
Tokyo 160-0022
Est. 1886

What started as a small kimono store in 1886 has evolved into a famous shopping destination known for its giant department store feel and high-end shops. The towering Isetan Shinjuku building sits squarely in the heart of the Shinjuku municipality and offers a little something for everyone—from furniture and stationery to an apothecary and shipping center. The dedicated kimono shop origins remain, and have been expanded to include other women's clothing, shoes, and bags. An entire floor is dedicated to food—with a fresh food market, Japanese sweet section, wine shop, and boulangerie. The intricate treats are a feast for the eyes and the stomach!

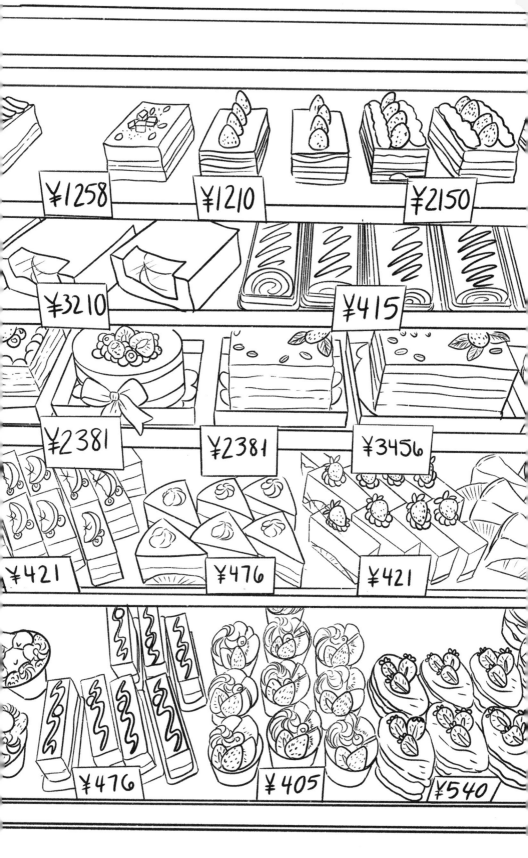

Maikoya Kimono Tea Ceremony

2 Chōme-19-15, 9th Fl., Kabukicho,

Shinjuku Ward,

Tokyo 160-0021

For a glimpse into an important facet of Japan's rich history, look no further than the traditional Japanese tea ceremony. On the surface, the ritual is simple, but it has a significance and spiritual purpose that is often overlooked. As tea ceremony participants sip on freshly prepared matcha, a bond is created between the host and the guests, and everyone enjoys a moment to focus on the simple act of serving and drinking tea. Maikoya does a wonderful job of bestowing that gift on guests, who can participate in the forty-five-minute ritual in an authentic environment. This location also offers a Japanese sweet-making class.

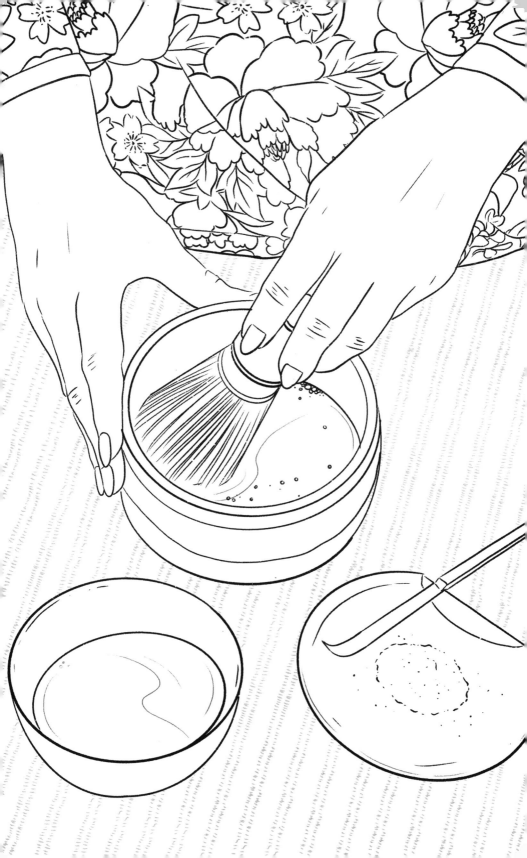

Shinjuku Gyoen National Garden

..

11 Naitomachi,
Shinjuku Ward,
Tokyo 160-0014
Est. 1949

Sandwiched between the bustling neighborhoods of Shinjuku and Shibuya is this expansive 144-acre park, which has Japanese, French, and English gardens. Its stunning glass greenhouse was built in 1950 and is filled with more than one thousand tropical plants and flowers. In the spring, Shinjuku Gyoen National Garden becomes one of the best places in the city to see cherry blossoms, especially in the English landscape garden, which has wide lawns surrounded by cherry trees. In the fall, the focus shifts to the Japanese garden and the maple trees on the east side of the park, which turn vibrant shades of orange and red in autumn.

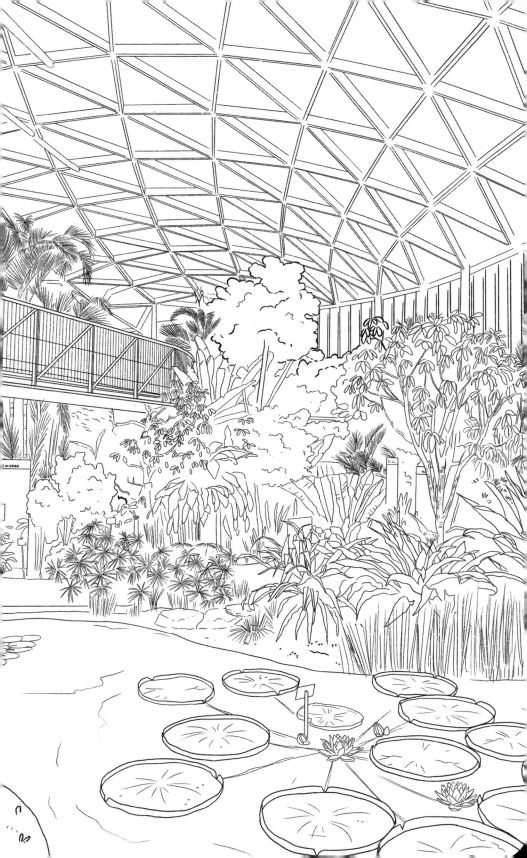

Shibuya Crossing

2 Chōme-2-1 Dōgenzaka,
Shibuya Ward,
Tokyo 150-0043

Whether crossing the street with around three thousand people sounds exhilarating or like your worst nightmare, there is no denying that the experience is memorable. The most famous example of a "pedestrian scramble," Shibuya Crossing is the world's busiest pedestrian intersection. Every few minutes, when the traffic stops, people pour off the sidewalks and into the intersection from every direction at once. When everyone meets in the middle, there's a moment of frantic sidestepping, bumping, and swerving before the changing traffic light provides a moment of calm—at least for foot traffic. The ongoing excitement takes place just outside Shibuya Station under a neon-lit intersection with giant TV-adorned skyscrapers and flashing advertisements.

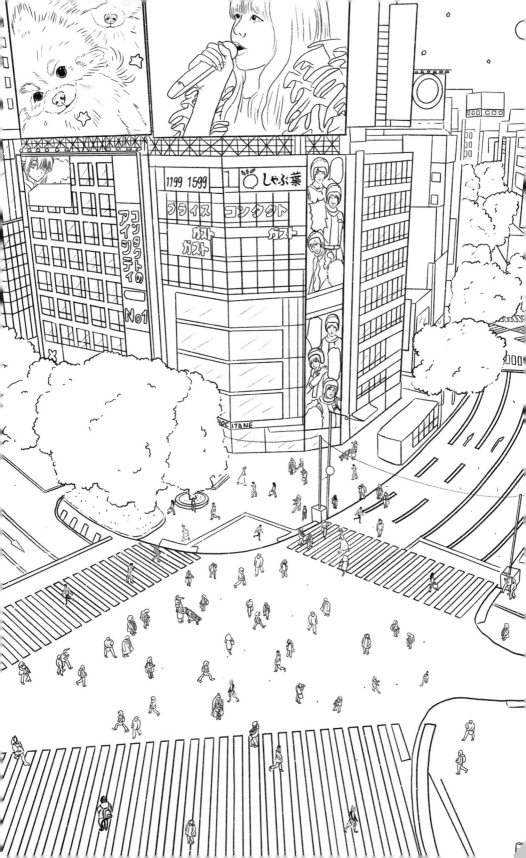

Uobei Shibuya Dōgenzaka

2 Chōme-29-11, 1 Fl., Dōgenzaka,
Shibuya Ward,
Tokyo 150-0043

Eating sushi in Japan is a must, but it wouldn't be Tokyo if they didn't take the experience up a notch. At Uobei Shibuya Dōgenzaka, a beloved "high-speed" sushi spot in Tokyo, you'll place your order on the multilingual tablet in front of your seat and be served within minutes via trays that zoom out from the kitchen. There are pages upon pages of sushi rolls to choose from, and you can sip on a bowl of miso soup and enjoy the free, on-tap green tea while you wait—which won't be long. It's perfect for people who know what they want and are looking for a fast and inexpensive meal that's right around the corner from Shibuya Crossing.

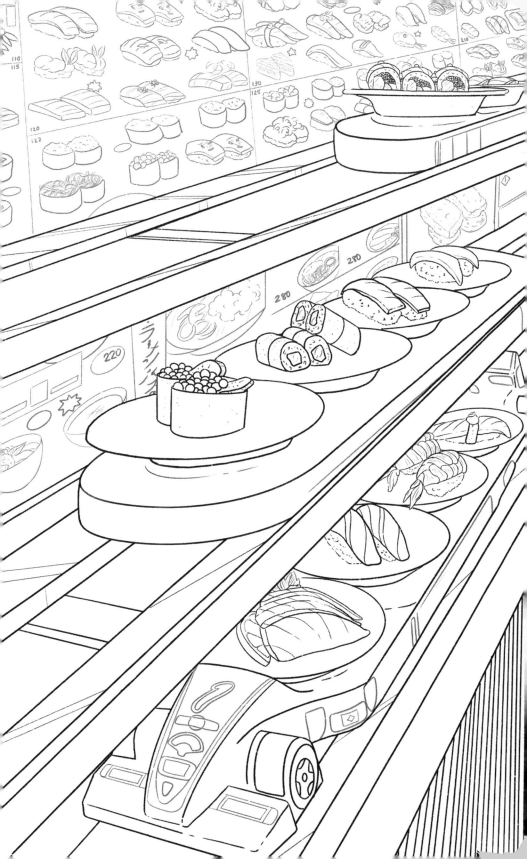

Karaoke Kan Shibuya

30-8 Udagawacho,
Shibuya Ward,
Tokyo 150-0042

Karaoke originated in Japan in the 1970s and is still alive and well today. But unlike karaoke in the United States, which often takes place at a bar, in Japan, karaoke is performed in a private room singers rent out with their friends. Each room has plush seating and disco lights, and some venues, like this one, rent out cosplay costumes so you can perform in character. At Karaoke Kan Shibuya, which was made famous because of a scene filmed in rooms 601 and 602 for the movie *Lost in Translation*, you can order bar snacks and drinks and pretend you're hanging with Scarlett Johansson and Bill Murray during a wild night in Tokyo.

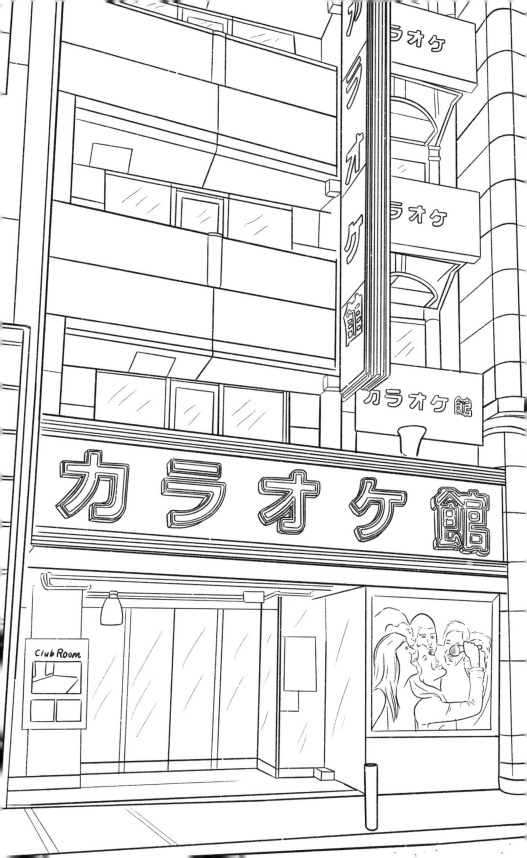

Meiji Shrine

1-1 Yoyogikamizonocho,
Shibuya Ward,
Tokyo 151-8557
Est. 1920

Once you pass under the *torii* gates that mark the entrance to the Meiji Shrine, it's hard to believe you're in the middle of Tokyo. The forest surrounding the path is thick and tranquil, setting the tone for the shrine itself, which is dedicated to the first emperor of modern Japan, Emperor Meiji. There are many routes to the shrine itself, which is nestled within Yoyogi Park, but the path from the southern entrance passes by a huge wall of painted sake barrels from brewers all over Japan. The belief is that people are closer to the gods when they drink sake, and while the barrels are empty, they make for a scenic arrival to Meiji Shrine. Before you pass into the main hall, make sure to use the water and ladles to rinse your hands and say a quick prayer. You can also write your wishes or prayers on the small wooden plaques (called *ema*) and hang them outside the shrine.

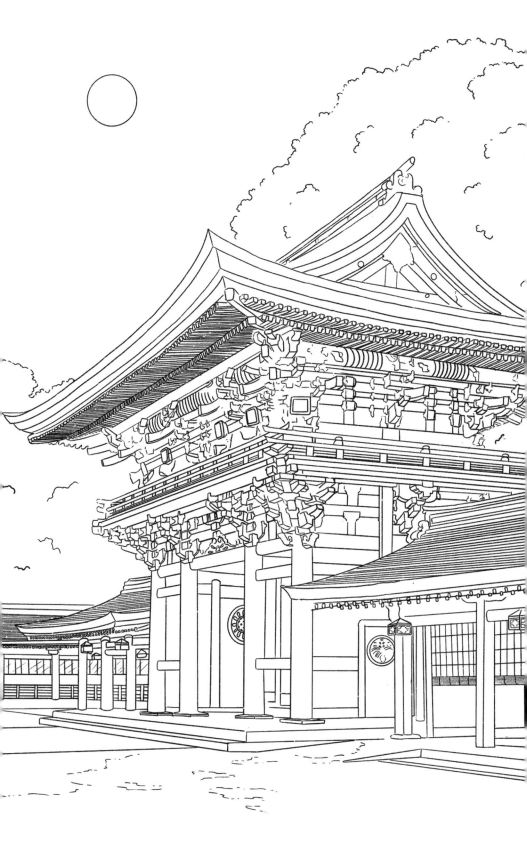

Yoyogi Park

2-1 Yoyogikamizonocho,
Shibuya Ward,
Tokyo 151-0052
Est. 1967

With a central location near the Harajuku neighborhood, Yoyogi Park is a perfect place to escape the bustle of the city and enjoy a few moments of peace. In fact, the park has become a top destination for picnickers who come to enjoy their lunch—or postwork drinks—in the park's wooded expanse. But instead of laying a blanket on the grass, people sit on bright blue tarps, and instead of packing a picnic basket of chips and sandwiches, visitors tend to bring along bento boxes and beer, which are best enjoyed on a makeshift table made out of a cardboard box. The setup is both clever and simple, and particularly special if you happen to find a spot under a blooming cherry tree or a golden-yellow ginkgo tree.

Harajuku

Jingumae,
Shibuya Ward,
Tokyo 150-0001

Tokyo's take on fashion can be seen all over the city, but the Harajuku neighborhood offers a particularly fun and concentrated peek into the fashion- and cosplay-obsessed youth of Japan. The streets are filled with people dressed to the nines, and while the entire neighborhood is vibrant and quirky, the heart of it all is Takeshita Street, which is practically a fashion runway. The busy pedestrian street is lined with vintage clothing stores, cosplay shops, and independent clothing stores with distinct styles—from the hyper-girlie Lolita (depicted here) to the steampunk- and gothic-inspired, as well as over-the-top *decora* and all things *kawaii* ("cute"). In fitting with its light, youthful feel, Harajuku is also the place to go for sweet crepes, donuts, and bubble tea.

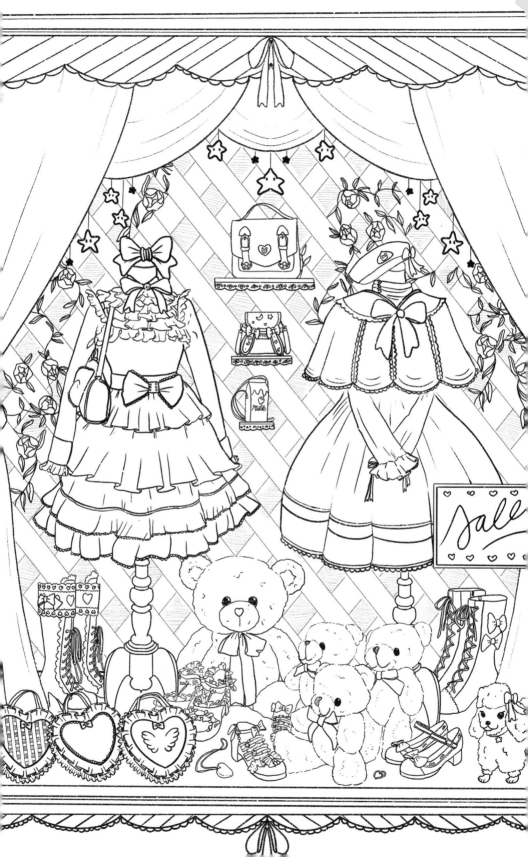

Cat Cafe MOCHA, Harajuku

1 Chōme-14-25, 4th Fl., Jingumae,
Shibuya Ward,
Tokyo 150-0001
Est. 2016

While the first cat café didn't open in Japan, as a notorious cat-loving country, they did quickly make the concept their own. Today, there are plenty of cafés where you can sip on a latte while snuggling, watching, and playing with felines of all colors and sizes. One of Tokyo's most beloved cat café companies, Cat Cafe MOCHA, has a great location in the Harajuku neighborhood and an unbeatable ambiance. Big picture windows look out over the city while a giant wooden cat tree provides endless play—and napping spots—for the café's furry residents. "Rice time," aka meal time, is a popular time to visit, but the twenty or so cats are also happy to enjoy treats available for purchase any time of day.

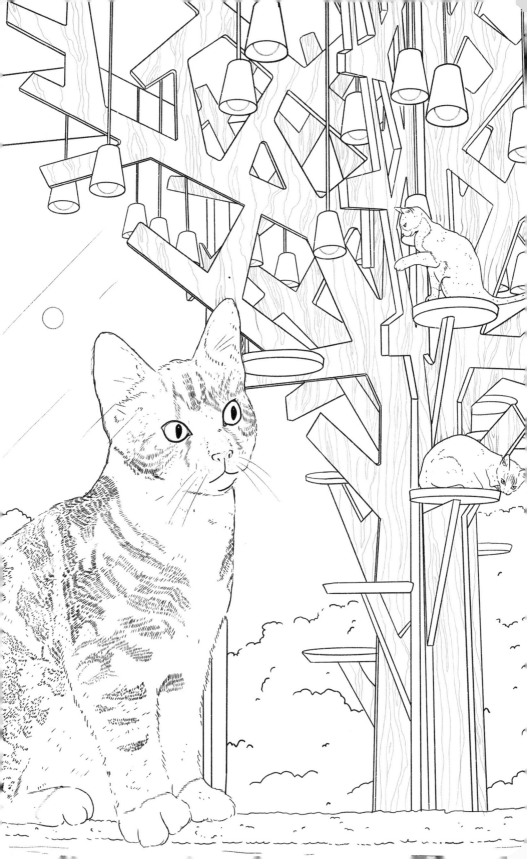

Inokashira Onshi Park

1 Chōme-18-31 Gotenyama,

Musashino City,

Tokyo 180-0005

Est. 1917

Inokashira Onshi Park has long held an important role in the city. The area was once the site of seven natural springs and the park's Inokashira Pond provided drinking water for the city. These days, the Ochanomizu spring still flows and the Inokashira Pond has become a popular spot for boating—especially in the spring, when the cherry trees that line the water are in full bloom and visitors can rent swan-shaped pedal boats. The small park has approximately five hundred cherry trees in addition to towering cypress and maple trees.

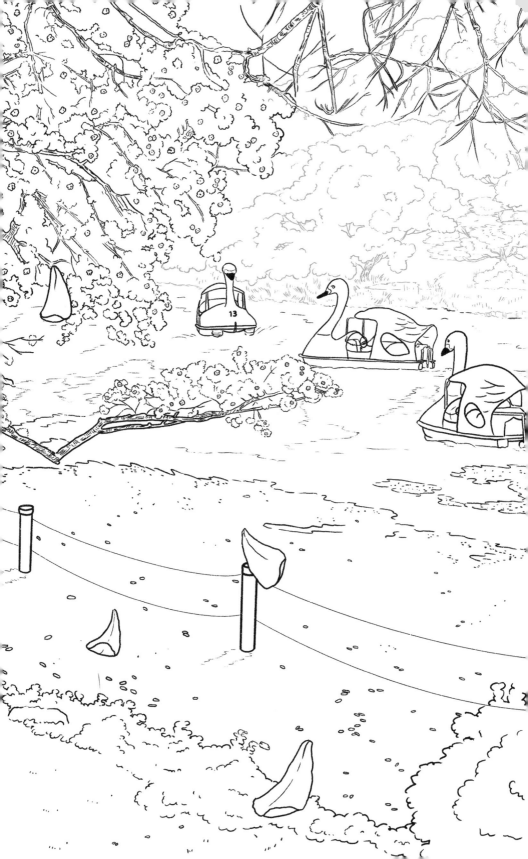

Yomiuriland

..

4 Chōme-1-4015-1 Yanokuchi,

Tama Ward,

Inagi City,

Tokyo 206-8566

Est. 1964

There's a little something for everyone—every day of the year—at Yomiuriland. The year-round amusement park evolves with the seasons, showcasing a different side of the park as the weather shifts. In the spring, you can zoom under the cherry blossoms on a roller coaster or take the sky shuttle for a bird's-eye view of the blooms. In the heat of summer, the park's five pools and three waterslides are a top destination, while the lights and illuminations are the biggest draws in the winter months. No matter the season, the brightly-colored giant Ferris wheel stands high above the other attractions, offering riders a panoramic view of the sprawling park. Throughout the park, you'll see nods to Yomiuriland's beloved mascots, two doglike creatures named Good and Lucky.

Mount Fuji

Shizuoka Prefecture, Japan

Mount Fuji plays an important role in Japanese culture. It is one of Japan's three sacred mountains, a revered pilgrimage site, and the subject of several iconic works of art. While Mount Fuji is not in Tokyo proper, the country's tallest peak can be spotted from the center of the city on clear days. The mountain sits within the Fuji-Hakone-Izu National Park and is surrounded by five lakes, known as the Fuji Five Lakes. The stunning mountaintop provides a bird's-eye view of the lakes, the Pacific Ocean, and the towns that scatter out from the base of the peak.

About the Author

Evie Carrick is a writer and editor who's lived in five countries and visited well over fifty. One of her favorite travel memories is the winter she spent skiing the Japanese Alps out of a camper van and the spring she spent living near the Sensō-ji temple in Tokyo. These days, she splits her time between a small town in Colorado and Paris, France, but still considers Japan to be the most interesting place she's ever traveled.

Grab Your Pen and Colored Pencils—and Travel the World!

PICK UP YOUR COPIES TODAY!